APERTURE MASTERS OF PHOTOGRAPHY

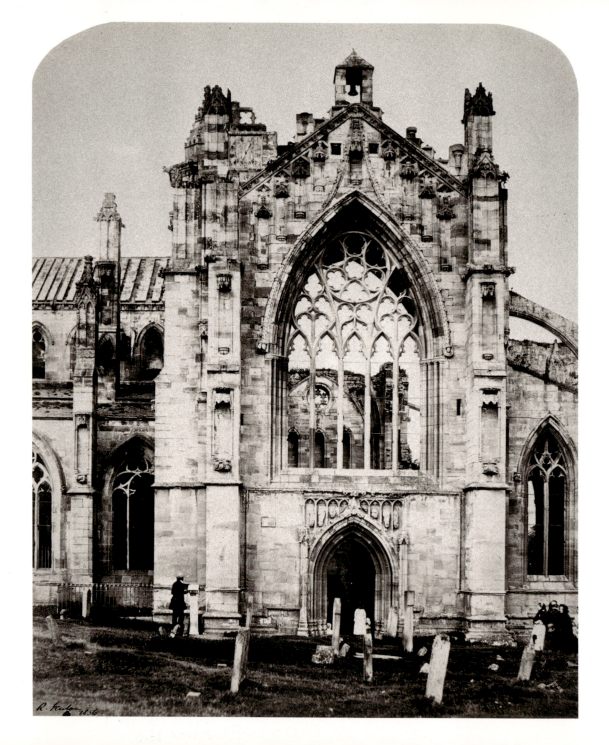

ROGER FENTON

With an Essay by Richard Pare

APERTURE MASTERS OF PHOTOGRAPHY

NUMBER FOUR

The Masters of Photography series is published by
Aperture. *Roger Fenton* is the fourth book in the series.

The photograph that appears on page 65 is from the
Royal Archives. Copyright reserved. Reproduced by
gracious permission of Her Majesty Queen Elizabeth II.
The photograph that appears on page 49 is from the
Rubel Collection, courtesy of Thackrey and Robertson,
San Francisco. The photograph on page 69 is courtesy
of Robert Lebeck, Hamburg. The photographs that
appear on the cover, frontispiece, and pages 27, 29, 33,
37, 39, 57, 61, and 93 are courtesy of the Collection
Centre Canadien d'Architecture/Canadian Centre for
Architecture, Montreal. All other photographs are
courtesy of The Royal Photographic Society, Bath,
England.

The quote that appears on the book cover is from the
book *Crown and Camera: The Royal Family and
Photography 1842–1910,* by Frances Dimond and Roger
Taylor. Published in England by Penguin Books Ltd.,
1987. Copyright © Her Majesty Queen Elizabeth II.

Series design by Alan Richardson
Library of Congress Catalog number: 87-070718
First Hardcover Edition 1981
First Masters of Photography Edition 1987
ISBN: 0-89381-270-6 (hardcover)

First Paperback Edition 1987
First Masters of Photography Edition 1987
ISBN: 0-89381-271-4 (paperback)

Manufactured in Hong Kong by South China Printing
Company.

Aperture Foundation, Inc. publishes a periodical, books,
and portfolios of fine photography to communicate with
serious photographers and creative people everywhere.
A complete catalog is available upon request.
Address: 20 East 23 Street, New York, New York 10010

Roger Fenton is one of the few universal men of photography. In the short span of eleven years, he was able to produce a widely varied body of work that represents one of the highest achievements in the history of photography.

Born in 1819, the second son of a mill owner and banker, he was well educated, and early on chose to follow a career in the arts. This seems not to have been a course that received great encouragement at home as he also established the right to practice law, being called to the bar and working as a solicitor. It was this career that he was to resume when he returned to law upon abandoning photography. He began his studies as a painter about 1839 and studied first with Charles Lucy, a member of the Royal Academy, and then moved on to a more advanced level of study in the studio of Paul Delaroche in Paris. He returned to London in 1844. He must have become a reasonably competent painter as his paintings were selected for exhibition at the Royal Academy each year from 1849 to 1851. These were probably typical sentimental effusions of a moral character, an aspect of his work that was to recur periodically throughout his career.

We now recognize his sojourn in London and Paris studying as a painter as preparation for his work in photography.

The studio of Paul Delaroche is famous in photography for two reasons: Delaroche was the man to whom has been attributed, apparently falsely, the celebrated remark upon seeing a plate by Daguerre that "from today painting is dead," and his studio was the place of study of four celebrated photographers, Roger Fenton, Henri Le Secq, Edouard-Denis Baldus, and Charles Nègre. In relation to Fenton the most important photographer is Gustave Le Gray, whose career in many ways parallels that of Fenton. The work of Fenton and Le Gray suggests that the photographers exchanged information and ideas relating to both the technical aspects of photography and aesthetic matters. It seems probable that they exchanged notes on technique, as Fenton was to use Le Gray's process in Russia. His printing has much in common with the aesthetic of Le Gray and bears a far greater affinity to the French attitude to print quality than does the work of any other British photographer during the same period. More interesting is the re-

markable parallelism in subject matter which seems to suggest more than casual coincidence. Each photographed marine scenes, Royal portraits, landscapes, major architectural edifices, military displays, and scenes of war or revolution. The late still lifes are the one category of subject matter that appears in a sustained series in the work of Fenton alone. By this time Le Gray had left Paris for Egypt after suffering commercial failure.

The career of Fenton as photographer is marked by great energy and ability put wholeheartedly at the disposal of the new art. Photography, still so seemingly miraculous, was probably the major artistic innovation of the Victorian era. Fenton was at the forefront of the campaign in England to secure for photography a status as an endeavor worthy of serious artistic consideration. Fenton was instrumental in the efforts to persuade William Henry Fox Talbot to relinquish the restrictive influence on the development of the medium that Talbot held through the patents on his acknowledgedly pioneering invention. He was one of the organizers of the Calotype club, a principal in the organization of the Photographic Society, and its first secretary. He was given the honor of escorting Queen Victoria and the Prince Consort at the first photographic exhibition in England, an exhibit that he had helped to arrange and in which he was an exhibitor. He was among the first photographers to document warfare, and among the first photographers in England to be commissioned by the Royal family to make Royal portraits. His contribution to the early history of photography is one of the most wide-ranging in all aspects of the medium, technical, polemical, and most important, aesthetic.

His attitude toward the aesthetic possibilities of photography was largely free of the restrictive effects of the academic training that he had acquired while studying as a painter, and he was able to use what he had learned of composition and organization of the picture plane in a way that was entirely suited to the photographic method. There are photographs by Fenton of such compositional audacity, such as the one of the Queen's target at the shooting competition, 1860, (p. 69), that their force and innovative skill are still striking. He was inventing a new language as he explored the possibilities of the medium and he had few peers who were able to keep up with his advances on the path of photographic discovery. He was often criticized by his contemporaries for the bold compositional devices that he used. These techniques were directly opposed to the norms of the day. He used the structure of the subject to increase the impact of a given composition and to give his pictures a rhythm and dynamic. Few of his contemporaries were able to evolve the same kind of compositional control of subject. Fenton found the means to unlock the hidden order in a landscape or release the harmony in architecture.

The work falls primarily into the following groups. In the early calotypes of Russia, Fenton evolved his early style. Then in the landscape and

architectural photographs made prior to his departure for the Crimea he experimented with the use of his photographic van (probably the first outfitting of such a portable darkroom). He sailed for the Crimea to document the events of the war. Upon his return he set out once more with a new van traveling widely across the country, adding a further group to his series of architectural and landscape photographs; he prepared a series of images in many different formats including stereo views, and small images in the range of eight by ten inches, and another intermediary size between this and the largest views, which are about fourteen by seventeen inches. At the end of his career Fenton published a series of elaborate still lifes. Interspersed among the major work are several subgroups: the portraits, the arabesques, the marine pictures, and the cloud studies.

The first works we know by Fenton are the pictures that he took on an expedition to Russia in 1852 where he was accompanying the engineer Charles Vignoles, who was constructing a bridge at Kiev. Fenton made a series of views of several cities including Moscow, St. Petersburg, and Kiev. These photographs show him already as a highly accomplished photographer. There is little hesitation in the choice of viewpoint. He makes pictures that are innovative and at the same time so assured that it seems that the photographic medium was perfectly suited to his temperament and abilities. He approaches the unfamiliar with confidence to produce photographs that explain and describe the prosaic and the exotic. He makes equally valid photographs of a ramshackle coach house as he does of the Cathedral of Saint Basil in Moscow.

When photography was announced in 1839, Queen Victoria had been on the throne for only two years and it was the beginning of a period of great political unrest. The balance of power in Europe was destabilizing and the first moves were being made in redrafting the political map that was to consume the military energies of much of Europe for the next eighty years. Photography entered this political forum rapidly with the development of the documentary technique, a field in which Fenton was a pioneer. When he was commissioned to photograph the Crimean war (1853–1856) he had already established a reputation for his technical ability, and the work that he carried out during the campaign demanded great ingenuity and the height of his creative skill.

He was commissioned by Thomas Agnew, the art dealer, to make a series of pictures that were to support the official view of the war and to describe the position of the allies for the population at home. They were made under the direct patronage of the Queen and the Prince Consort and as a result of these restraining factors they show a more positive side to the campaign than Fenton might have made given a completely free hand. In this substantial set of 306 pictures he published many portraits of the leading commanders and produced elaborate set pieces purporting to show instantaneous views. These portrait groups were

carefully posed and arranged in plane to minimize the disadvantages of the difficult conditions imposed by the very slow materials that required lengthy exposure times. These exposure times became ever longer as the weather grew hotter.

Among these pictures, essentially descriptive of the personages and the terrain of the campaign, is one of the first truly memorable views of war. "The Valley of the Shadow of Death" is probably the first photograph to bring home vividly the full horror of war. In its stillness and silence, empty of any human life, it gives a vivid impression of one of the last engagements of the old kind with cannon, rifle, and bayonet. The picture in question shows a slight gully in the battlefield in which all we see is churned up ground turned to mud by the tracks of many vehicles that have run the gauntlet that was clearly a precisely located target for the enemy batteries. The surface of this otherwise unexceptional piece of ground is scattered with innumerable cannonballs that give a vivid impression of the noise of war and sudden death filling the air. So many of these spent shot are scattered about within the frame of the image that we understand the heroism of the men faced with imminent mortality in the course of duty. For Fenton and his assistant, as free agents, to go about the laborious business of transporting the photographic equipment in the specially adapted wagon, to take the risk of setting up his camera, preparing, and making an exposure in the same deadly circumstances suddenly becomes an act of extraordinary

daring, if not of heroism. This powerful photograph is all the more remarkable as it is the only one in the whole portfolio that uses metaphor in an effort to explain the true nature of war. He recognized that it was possible to record the devastation and upheaval of war. In this forceful revelation of the destructive instincts of man he fixed the standard to which all later work in the battlefield has aspired.

Upon his return to England he continued his series on cathedrals, country houses, and landscapes (predominantly of river scenery). Fenton's greatest architectural photographs are often meditations on the nature of permanence and change; he evokes summer days and the glorious minutes after dawn and the strange lingering half light at the end of the day when the shadows are long and the surfaces of ancient stone walls seem to be illuminated from within. In the landscape photographs he displays his ability to clarify the subject before him through the limited and particularly photographic tools of organization and selection. Able to see the potential in the large view and equally in the sharply observed detail, he photographs the fisherman's contemplative sport on the river bank and records the catch showing the glittering beauty of fish still bearing the brilliant sheen of life which fades so soon after the sudden and desperate struggle against the lure.

In the work of Fenton interpretation of the idea of time is central. Apart from the inevitability and stillness of the photographic representation of time

he also considers time as the expression of change and as the expression of continuum. The modest but beautifully conceived photograph of the doorway of Rievaulx Abbey suggests many different attitudes to the problem of time in photography in one image. The picture shows the gateway to the monks' burial ground and is, a priori, infused with the idea of mortality. This is extended into the present moment of the photograph by the tranquil figure of the woman reading. The child seems to stand for anticipation of the future as she is forever arrested in the act of climbing the fence into the adjacent field; each figure suggests symbolically the progression through life to maturity. Through both these figures, now dead, we look at the elision of time from our own position in the future of the photograph.

Two of the most daring of all his photographs are composed with rigorous formalism. The first is the long walk at Windsor, one of a series of thirty-one views of which the great print presently known is in the Royal collection at Windsor. In this remarkable image the composition is divided into sharply defined areas that can be read abstractly on the flat surface of the picture plane or equally as the drive that rushes to the horizon and the unmistakable silhouette of Windsor Castle. The second is perhaps the most startling in the complete work. It is a representation of the Queen's target at the shooting competition at Wimbledon on the second of June, 1860. The picture is the record of a piece of gallantry by the officers in charge of the

arrangements for the reception of the Queen. An elaborate apparatus, (a contraption that appears in another of the photographs in the set), was contrived for the Queen, who by pulling a string could release the trigger of a rifle that had already been lined up very precisely on the target. It shows only the target, precisely framed, that has been prepared with broad strokes of the brush. The single bullet hole in the inner circle is as close to the center as the mechanical marksman was able to achieve. The result of this complicated deceit is a picture that has no artistic parallel until the second half of the twentieth century. It is not the incident of the shot but its starkly abstract presentation and the decontextualization of the subject that gives the image its power.

Fenton's range and versatility are well demonstrated if we consider next his short series of arabesques. These pictures of a young woman wearing Middle Eastern clothes, bearing the symbolic accoutrements of the woman at the well, seem to have been inspired by the idea of Rachel, or La Source. Perhaps he knew the celebrated painting of Ingres and gave to the same subject a more realistic turn. These pictures were made with great attention to detail and in those of the water carrier even the blue tattoos on the chin are shown.

The great reclining *Odalisque* is a summation of a nineteenth century genre. Through a popular fascination with the idea of orientalism it was fashionable to adopt a quasi-Eastern pose and portray a kind of decadence full of erotic promise which

could pass the censorious attitudes of the public through its exotic context. All of these pictures seem to be of the same model; in each she is carefully presented as odalisque in the harem, or peasant woman having returned from the well. The photographs are clearly fictions but in spite of this there is sufficient attention to the details of context and environment to make the fiction convincing. Who the model was for this short series of Eastern fantasies we do not know but she seems to have been a woman of some magnetism capable of conveying a deep sensuality. Whether or not she was dressed up in Turkish or Arab costume she is not simply posing but is assuming the role. Even in the simplest of these pictures her magical femininity stands out in spite of the passing of time and the change in attitudes.

Who are the people in the photographs of Fenton? What is their function? Who are the men who stand in the doorways of the cathedrals? Are they there simply for scale or are they actors in an unending drama that will last as long as time? There seems to be a dramatic intent in many of the figures present in the photographs; a conversation is in progress or a party in mourning is leaving some hallowed ground. It is impossible to say what Fenton's intentions were in any precise way. He invokes our emotions and subtly reinforces the atmospheric qualities of his picture by the inclusion of human detail.

Throughout his career, Fenton worked with many photographic techniques and all the formats that were available to the photographer of his day. On his Russian expedition he produced some of the earliest stereo views for the Wheatstone viewer (that used a principle involving mirrors) that was to be replaced shortly after by the more familiar stereo viewer for which he produced many pictures. In the Russian pictures, he used Le Gray's waxed paper process, and upon the development of collodion, he turned to glass for the rest of his output. In this difficult and intractable technique, he produced a number of masterpieces that stand in the foreground of the history of photography. His printing methods are also of the most innovative and painstaking. He produced prints with great range of tone and color which, in many cases, appear to have been selected according to the appropriateness of a particular color to a particular subject. The prints run through a spectrum of blue grays to warm golden hues and on toward the red tones. The luminosity of his prints at their best is a testament to his understanding of the manipulation of his materials.

The history of Fenton's work is complex with few major holdings of prints in collections assembled at the time the photographs were printed. Much of the work has been scattered and much may have been lost at the time of the dispersal of his effects. The largest single collection of his works, the gift of his descendents, is housed at the Royal Photographic Society at Bath. However, this collection is not complete. A large collection of his prints is held by the Royal collection at Windsor

where they have been well maintained. This collection, formed at the time the prints were made, focuses primarily on subjects connected with the Royal family and contains some of the most perceptive early portraits of children. Other groups of prints are to be found in many public collections.

Why did Fenton retire from the field of photography to return to his practice as a solicitor? It may be that in the eleven years of his activity as a photographer he felt that he had fully explored the vocabulary of the medium. After completing his last set of works, the still lifes of fruit and objects for which he received immediate recognition, he seems to have turned his back without regret, and left photography to find its way without his powerful voice. It should be noted that it was a time when the first decline in photography was just beginning. Photography had become technically much simpler and this brought many more competitors into the field, reducing demand and decreasing revenues. It was therefore a time of declining profits for Fenton, who, during the height of his activity, had received the sum of nine hundred pounds from the British Museum in one year. In November 1862, he sold off all his equipment and negatives at auction. Some of the negatives were purchased by Francis Frith, who continued to print from them long after Fenton's death. Frith became the most successful of the early publishers of photographs with a stock of negatives by many different photographers, some of which are still being used today.

Fenton's resignation from the Photographic Society was noted with great regret by the membership. It is unclear whether he ever participated any further in the issues of the Society during the last seven years of his life. There is the impression that he was not a man of robust health and that he may have returned to his law practice as a solicitor having found the arduous demands of photography beyond his strength.

In his photographs, Fenton was capable of magisterial summation and intimate detail, each freighted with a forcefulness and an inner conviction that has rarely been maintained over such a wide range of subject matter and at such a high level of achievement. He gave psychological insight to his portraits, structural understanding to his architectural views, and atmospheric allusion to his landscapes.

Of all his contributions to photography, Fenton's most significant legacy is the work itself. He stands high in British photography as the first deeply influential force, who through energy and ability was to have a lasting impact on the entire subsequent history of British photography. He was varied in his output and had so fine a grasp of the potential of the medium to stimulate the imagination, to tell the nature of things, and to leave behind suspended moments of time to be savored in the future, that it will take far longer than the brief period that has elapsed since the conclusion of his short career before we are fully able to understand his position in the pantheon of art history.

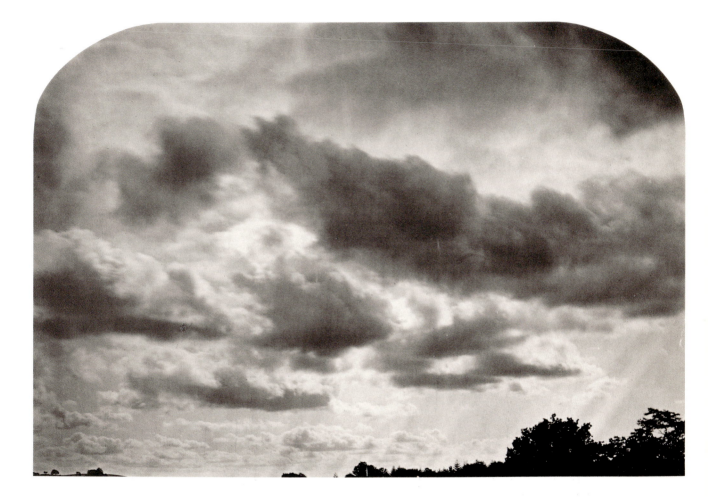

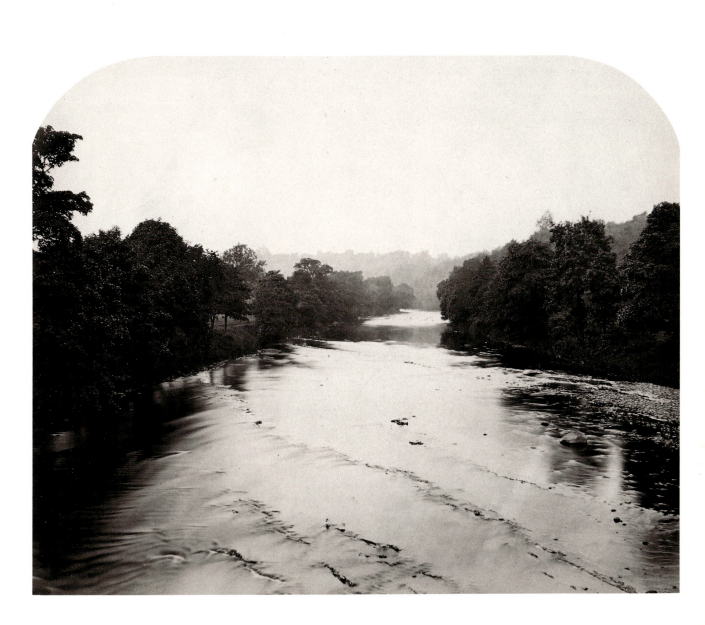

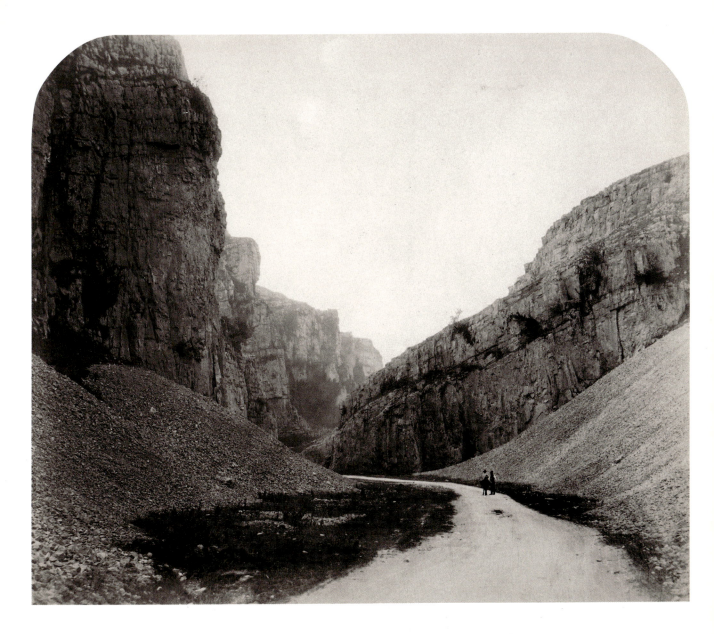

17

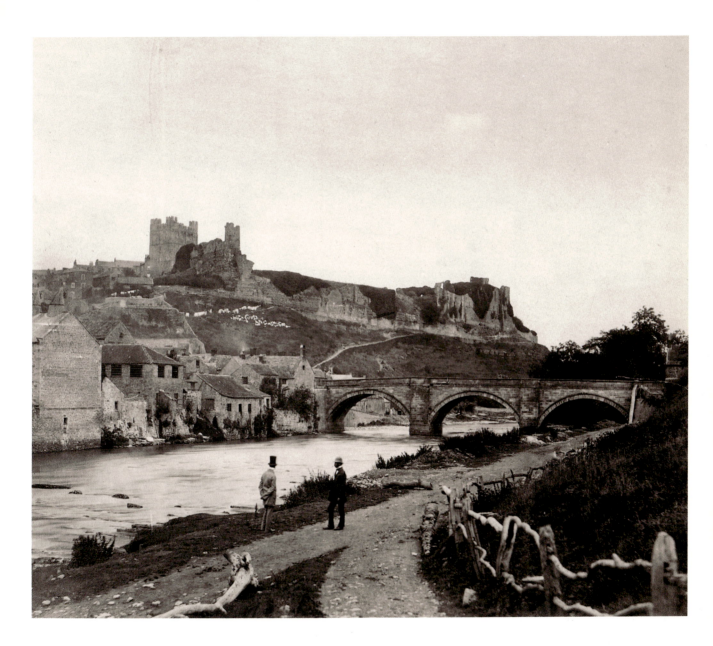

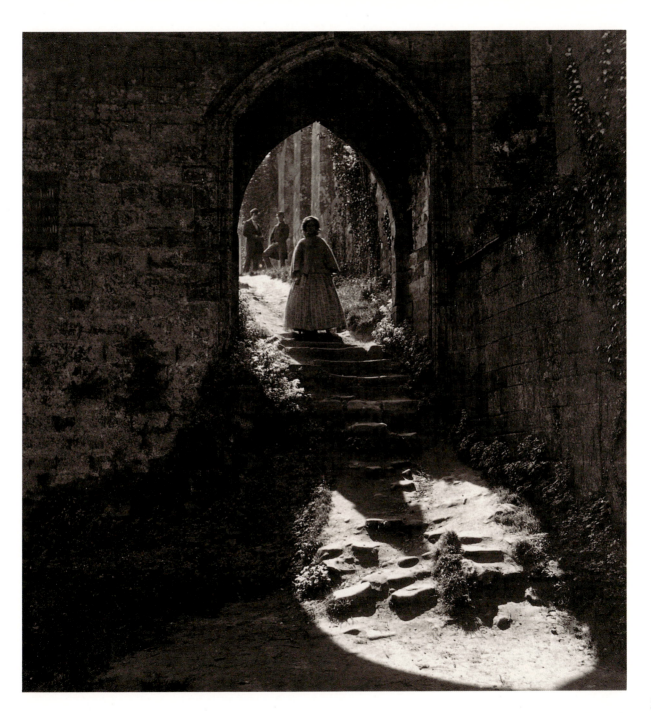

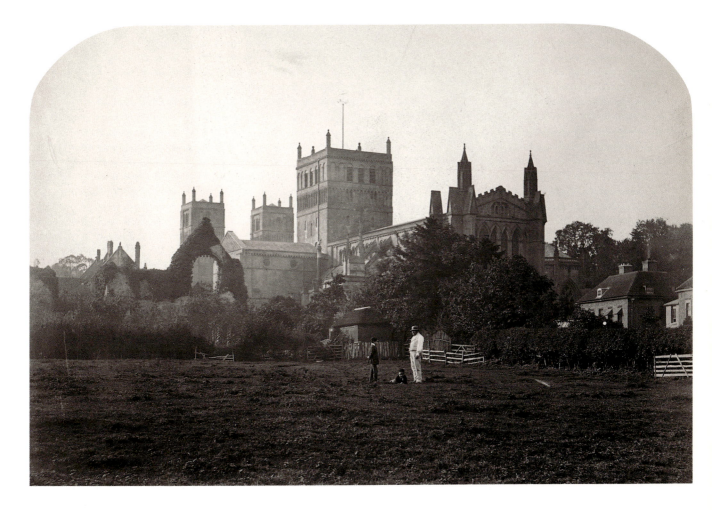

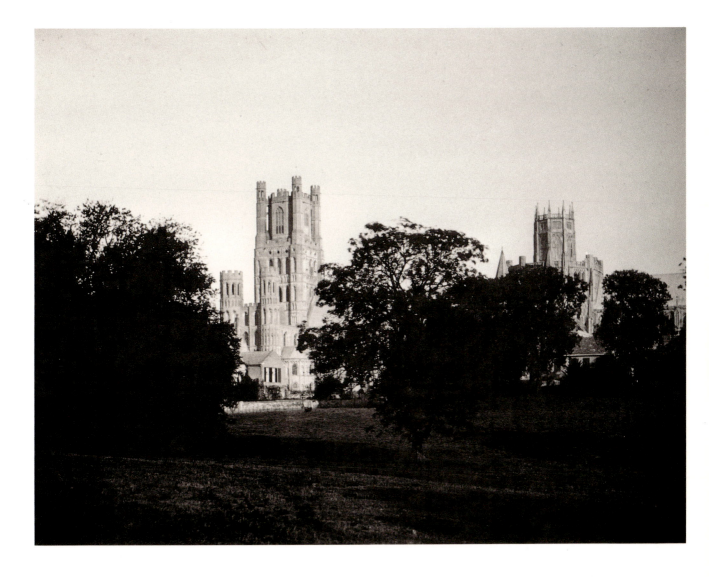

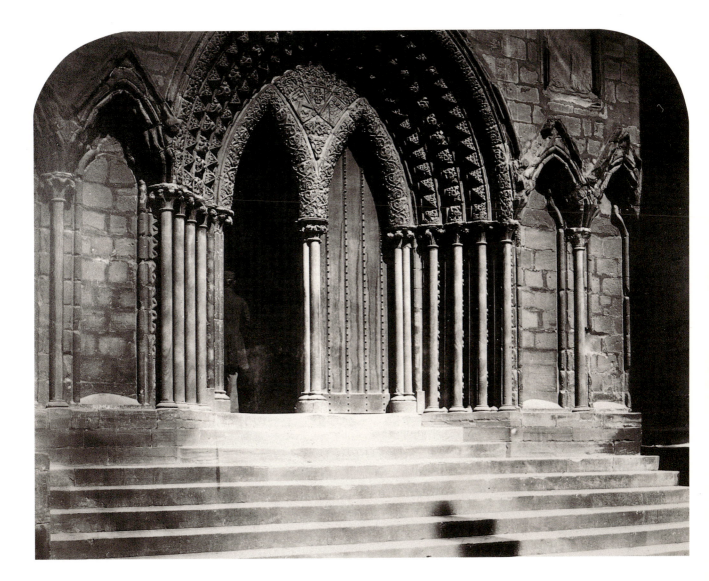

29

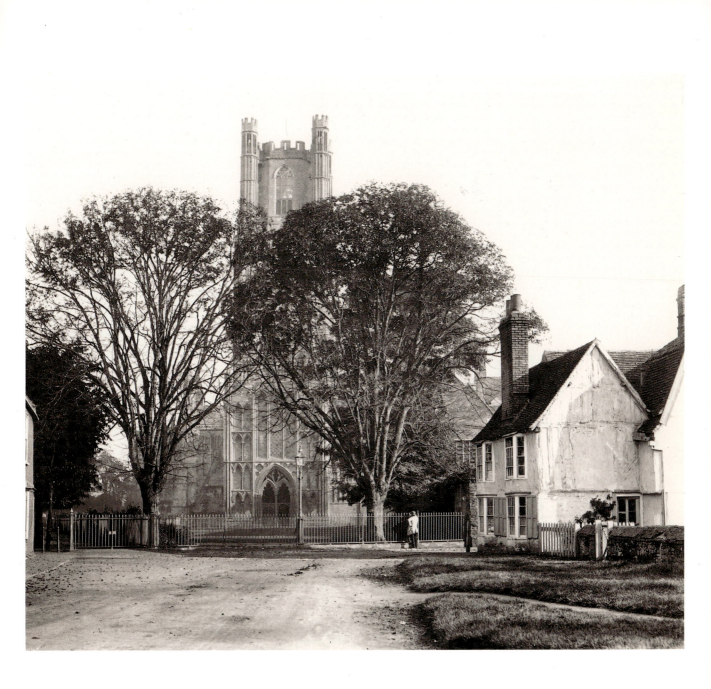

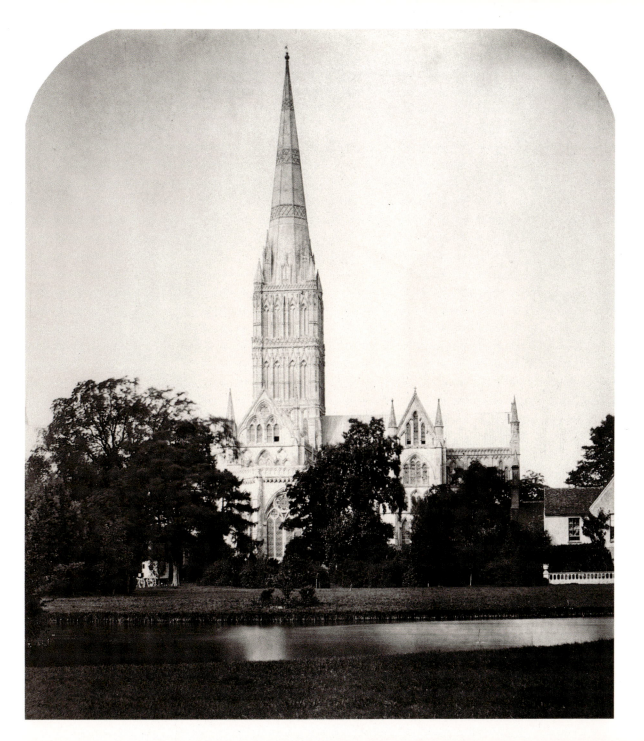

33

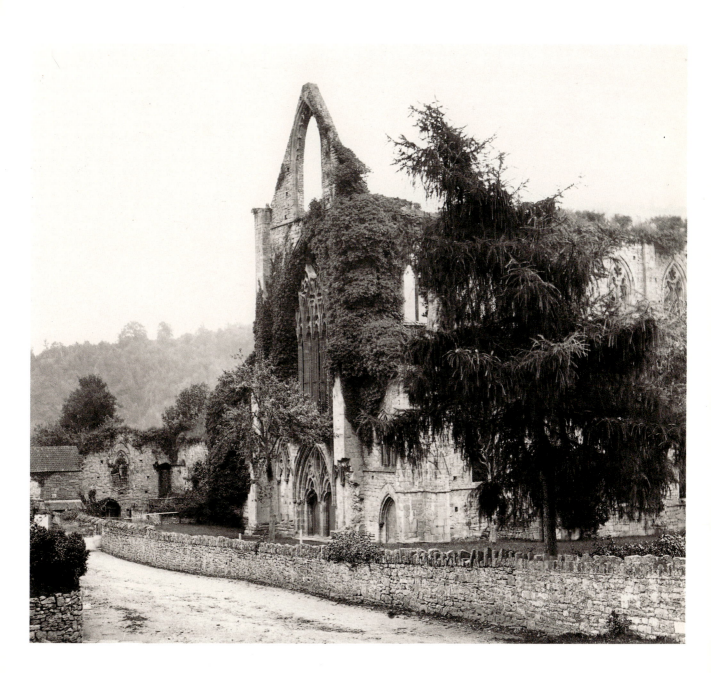

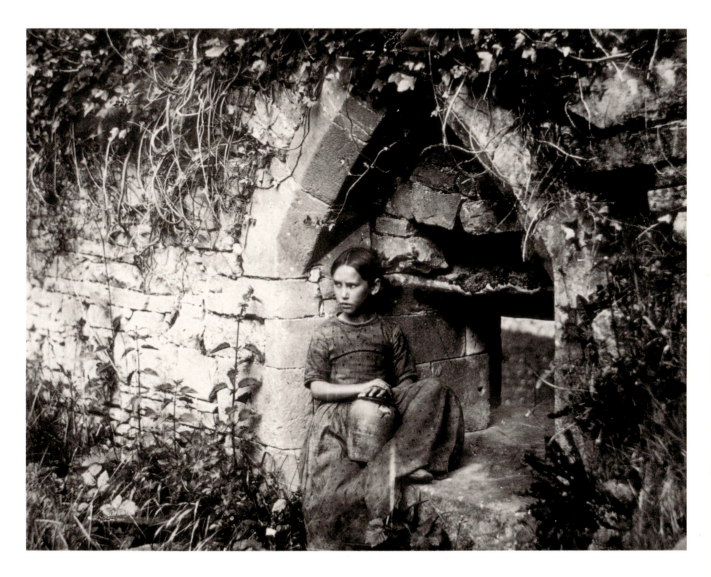

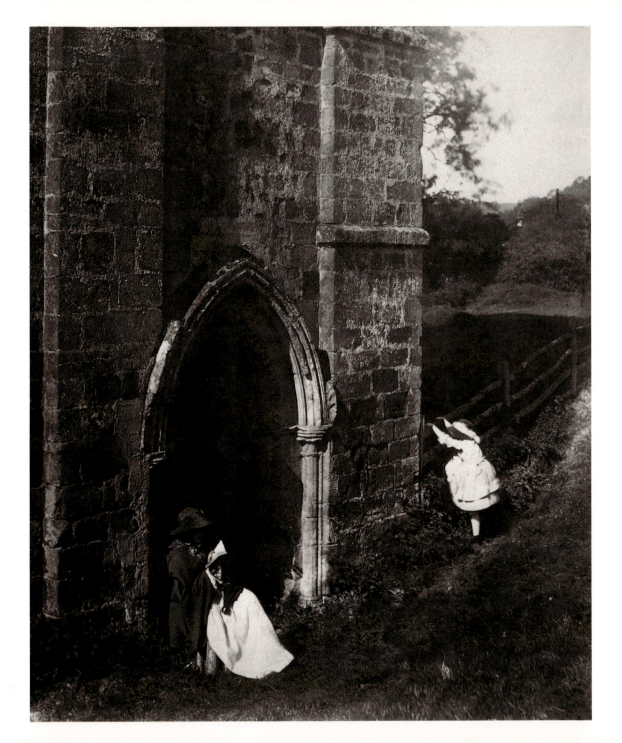

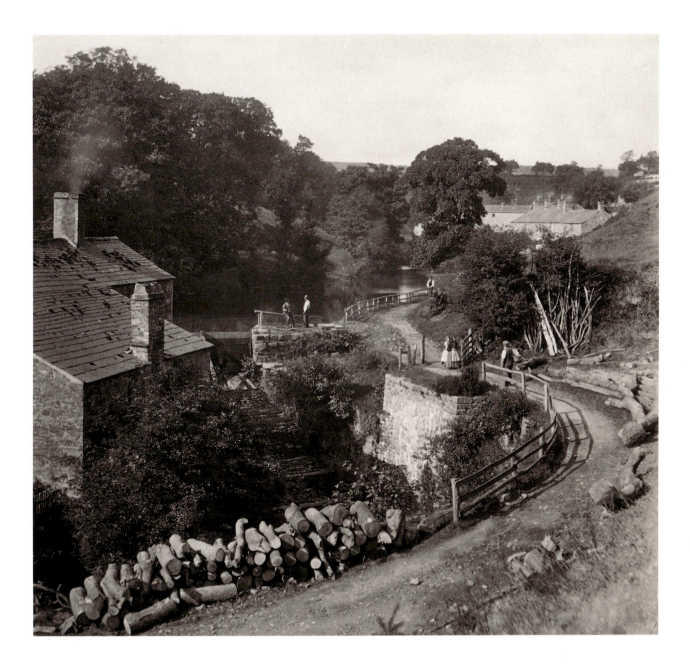

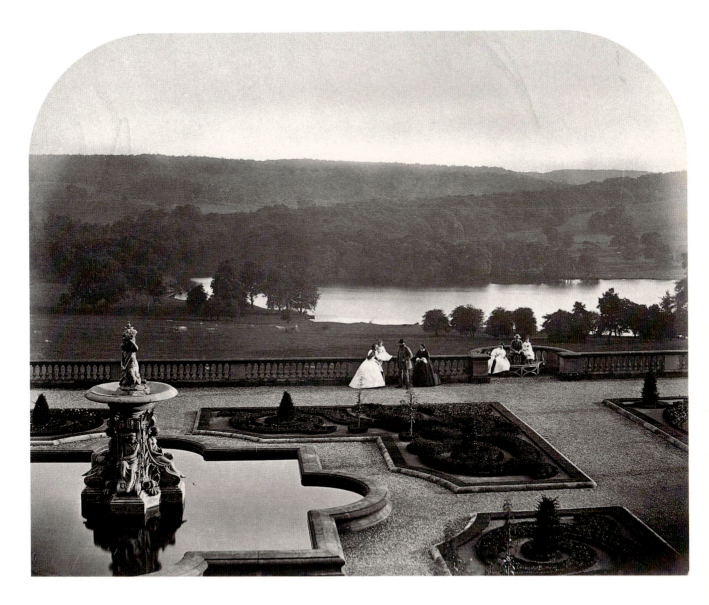

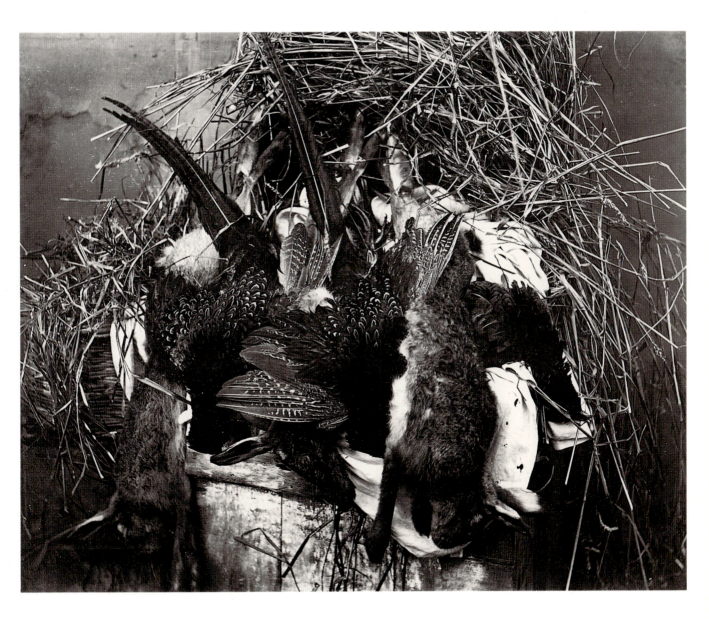

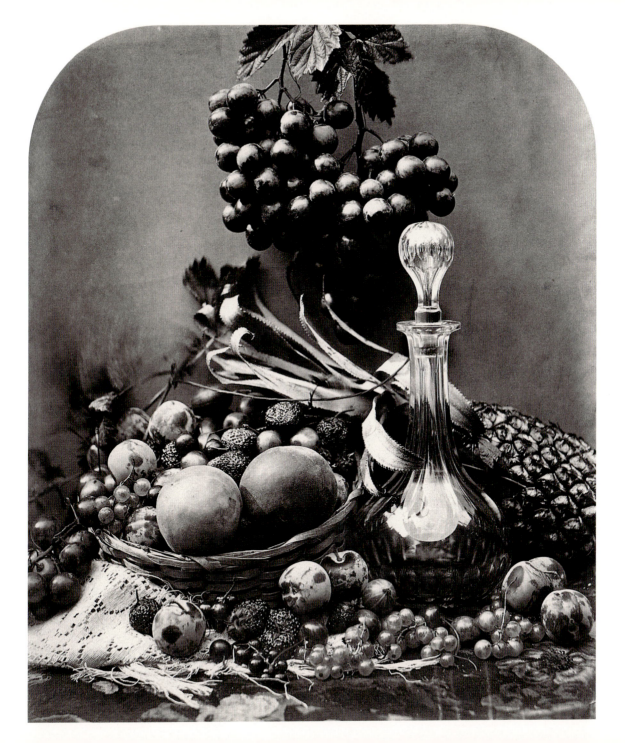

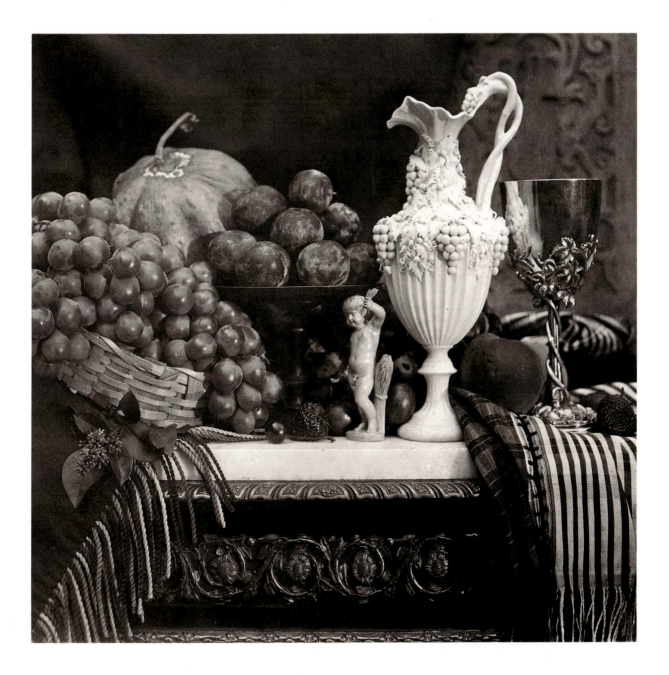

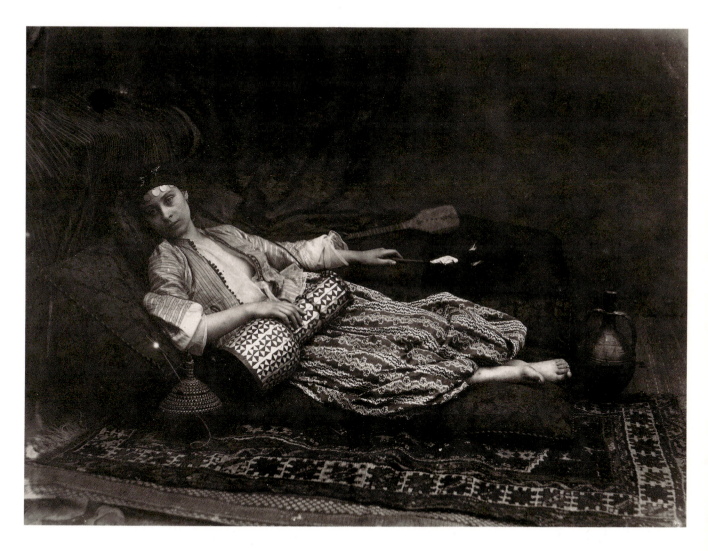

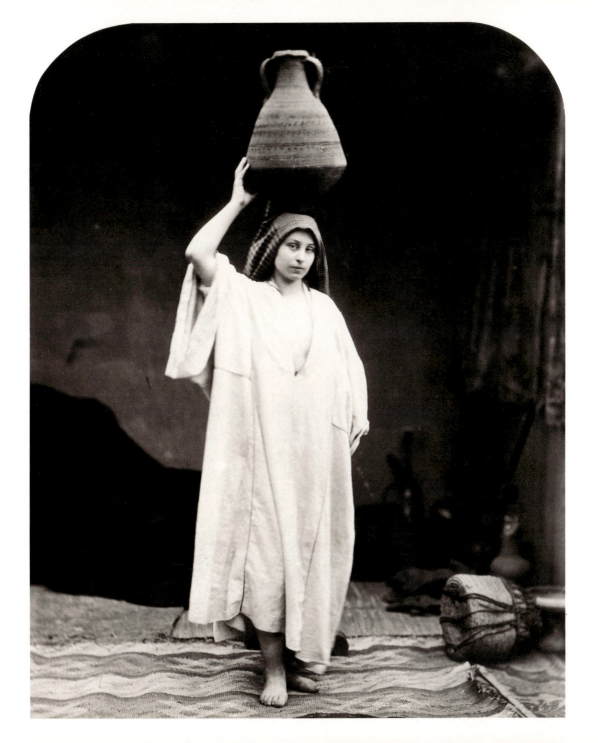

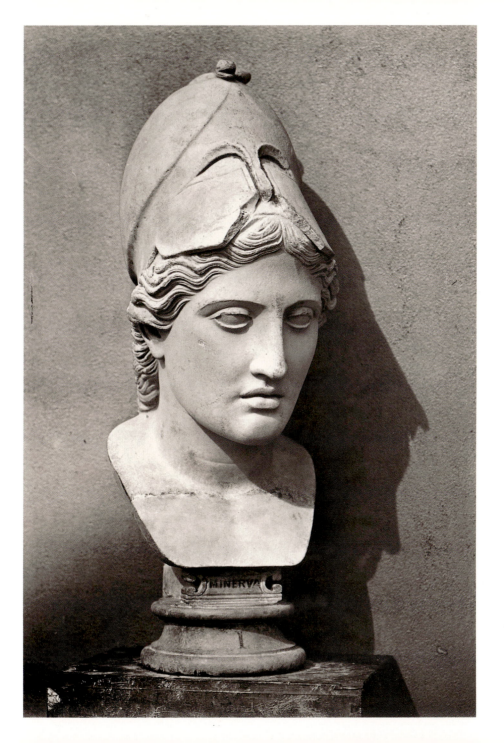

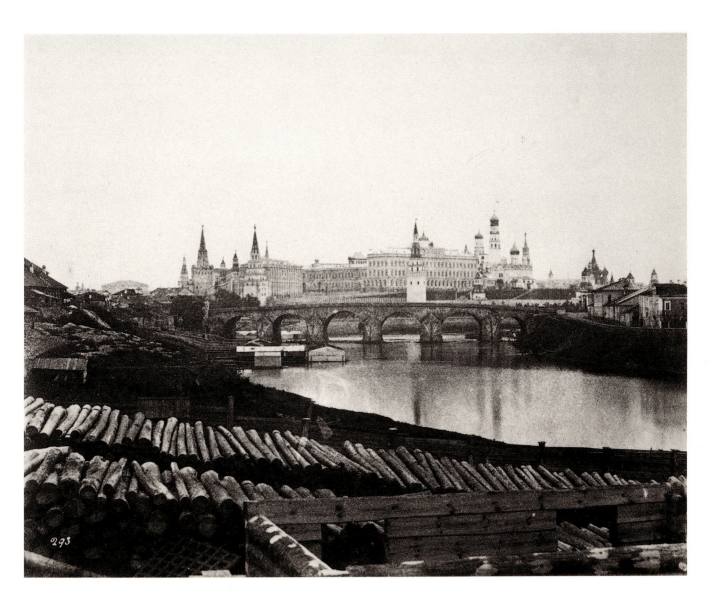

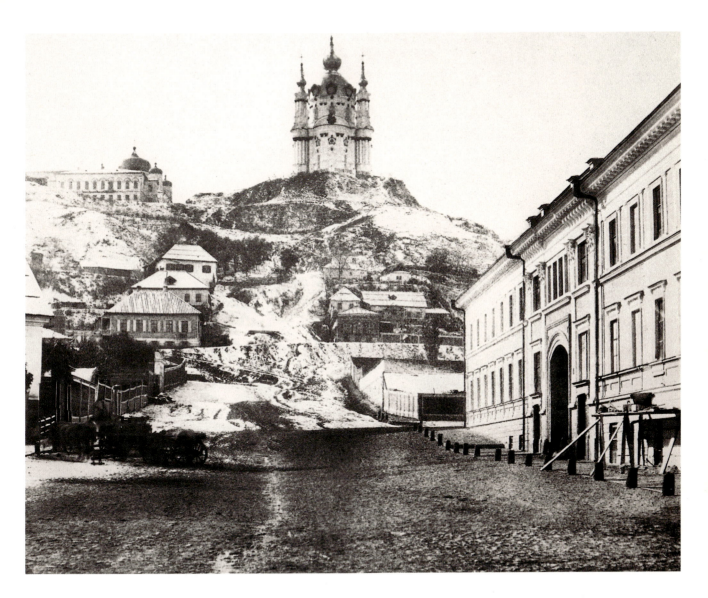

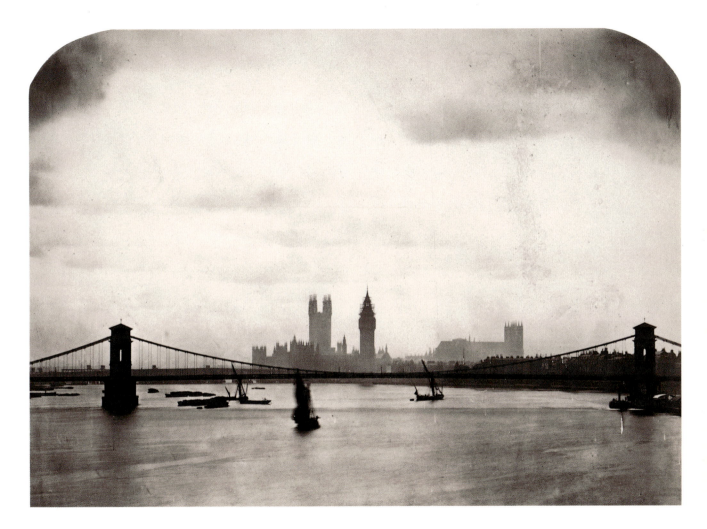

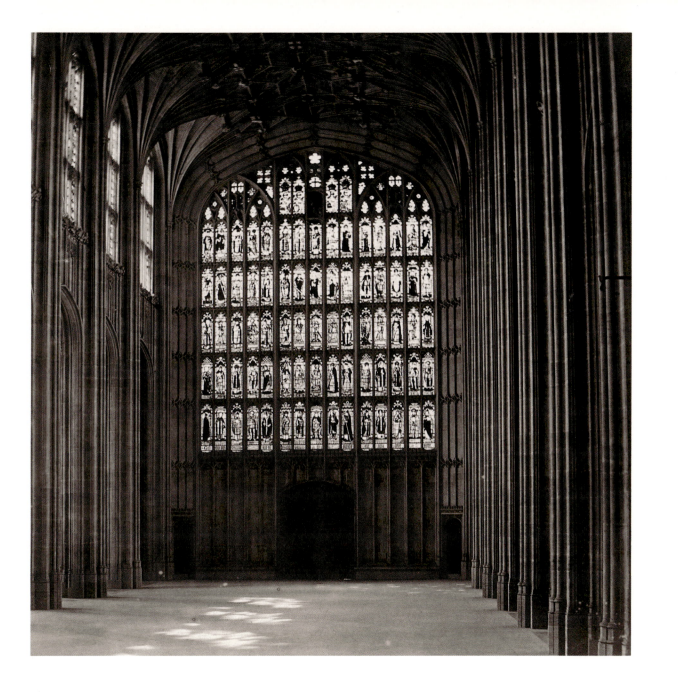

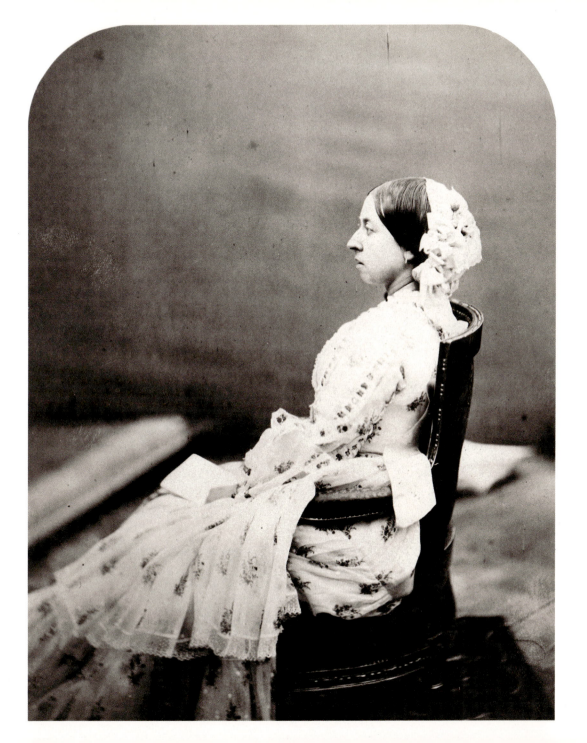

65

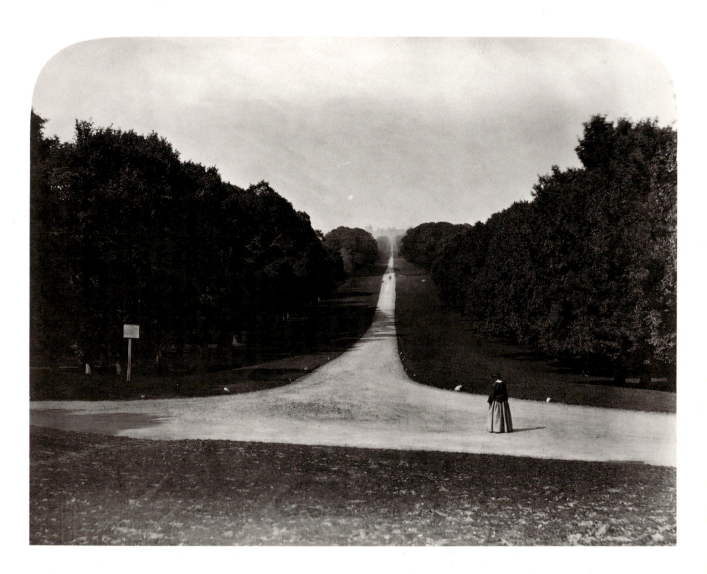

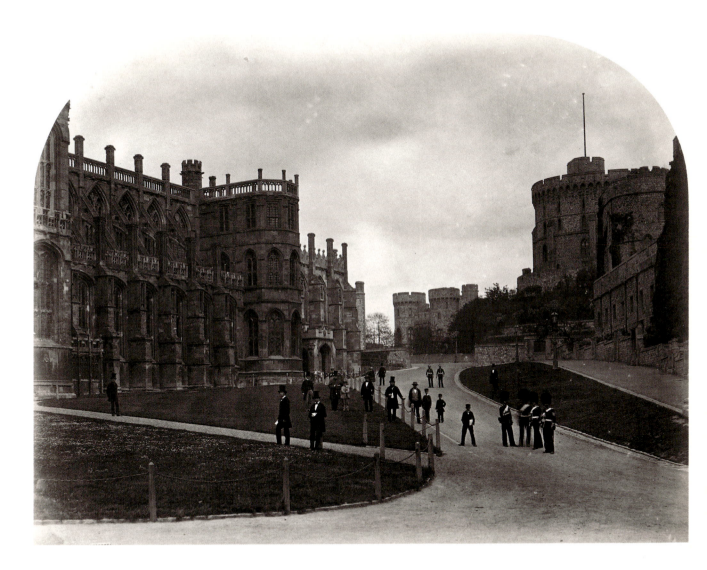

69

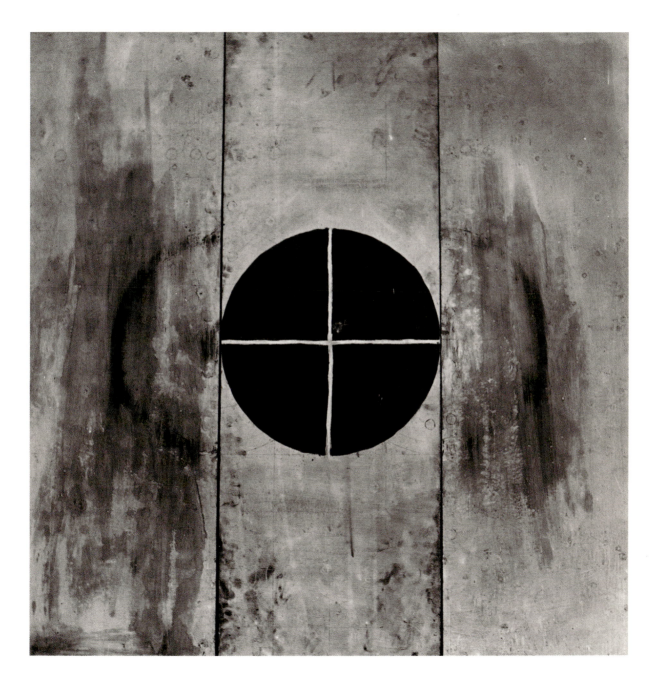

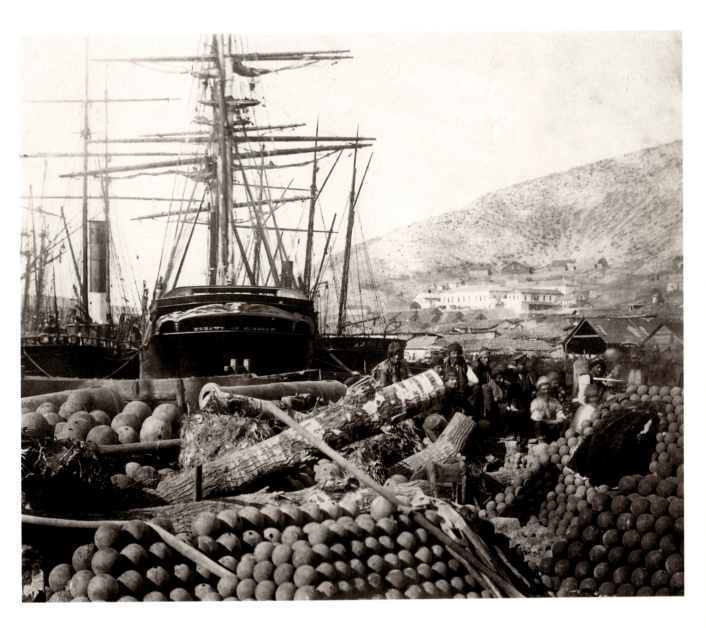

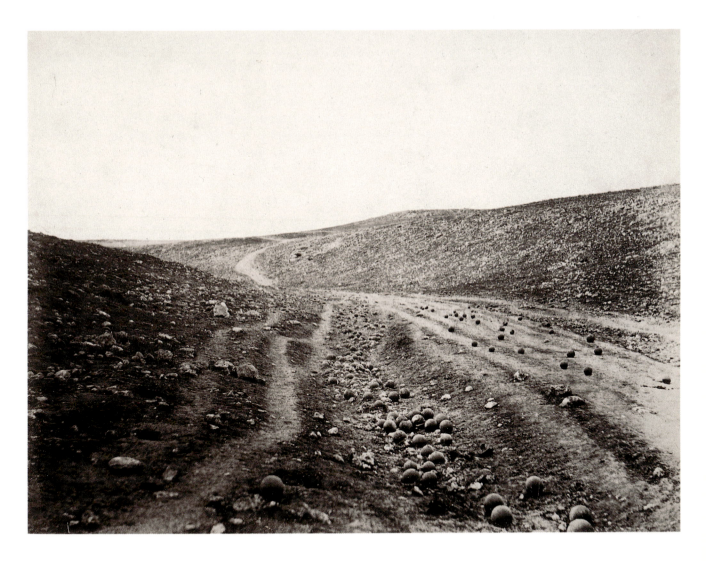

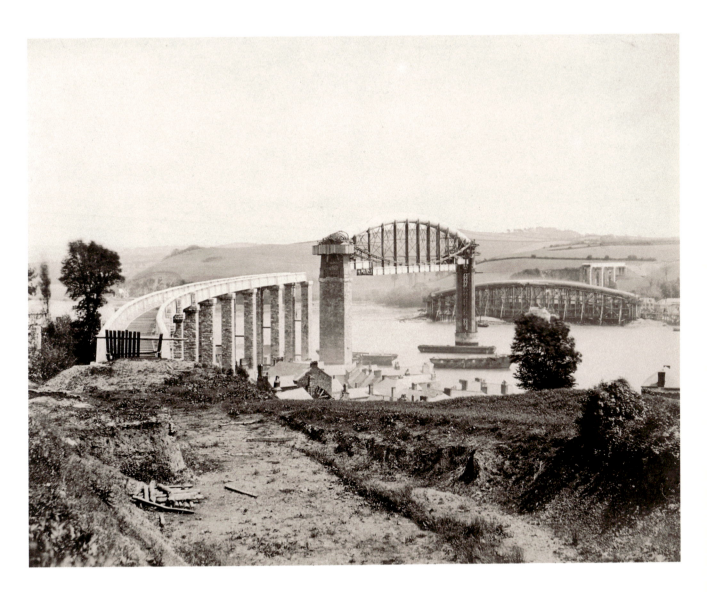

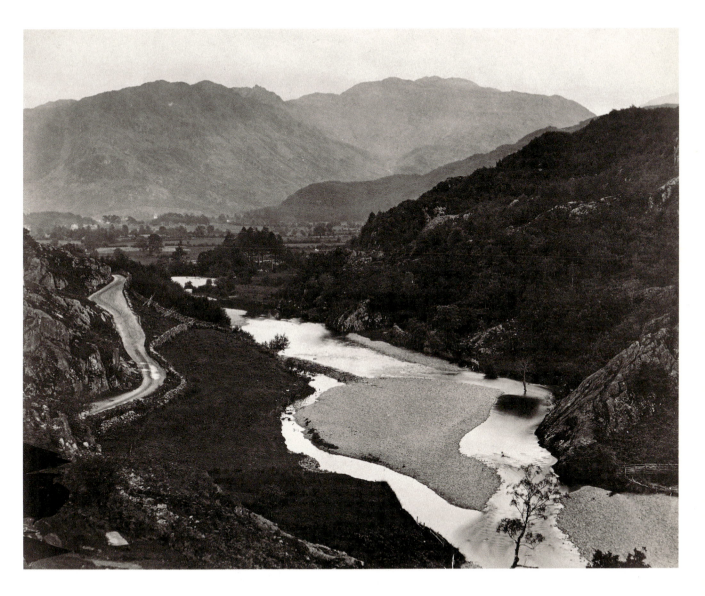

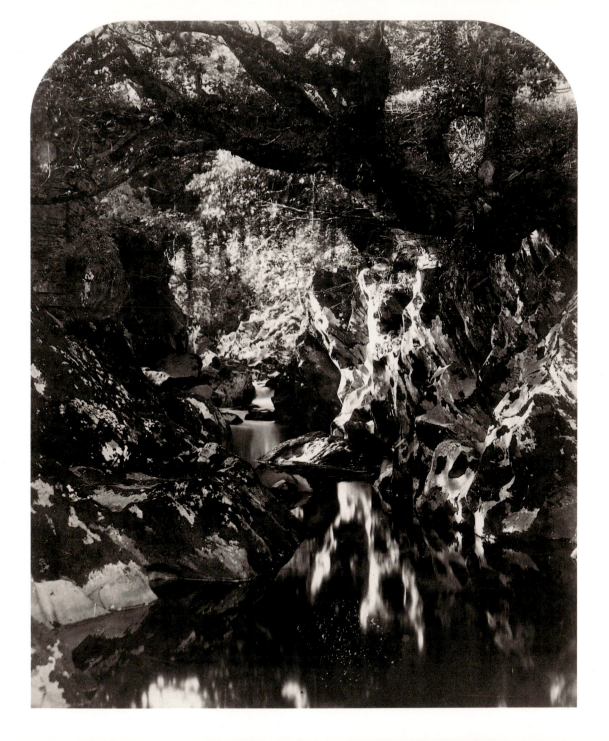

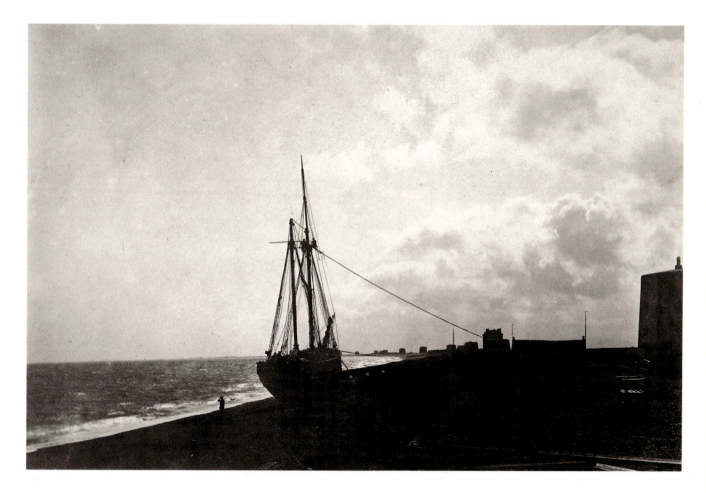

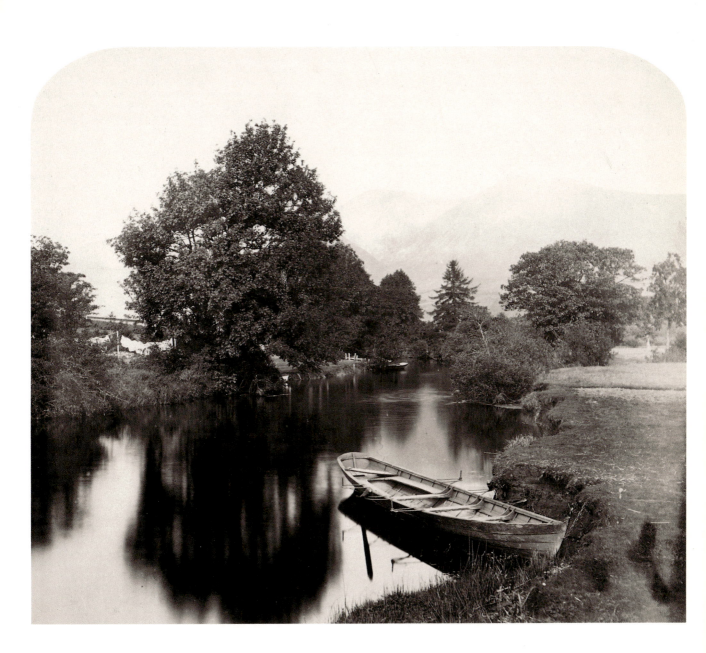

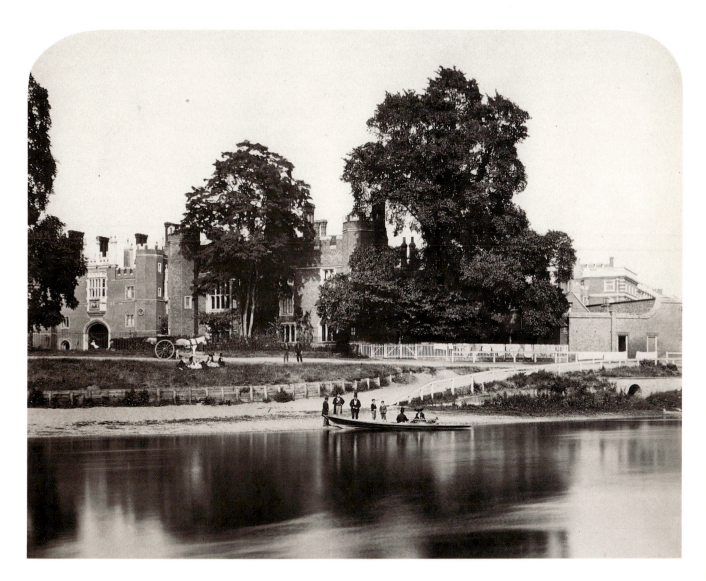

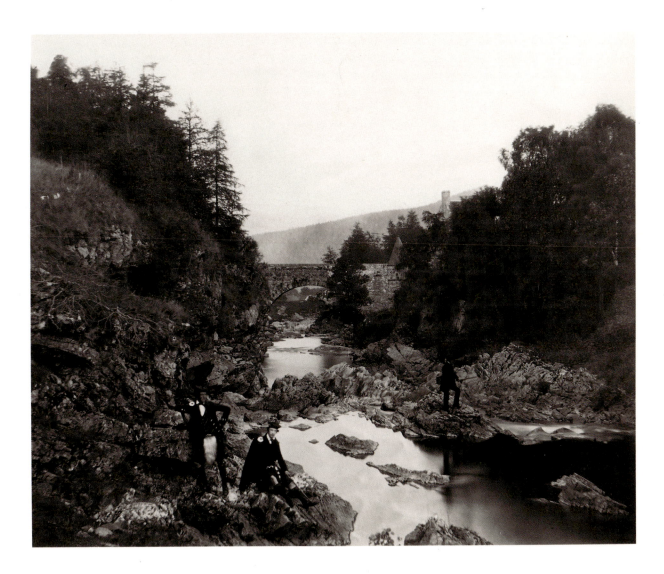

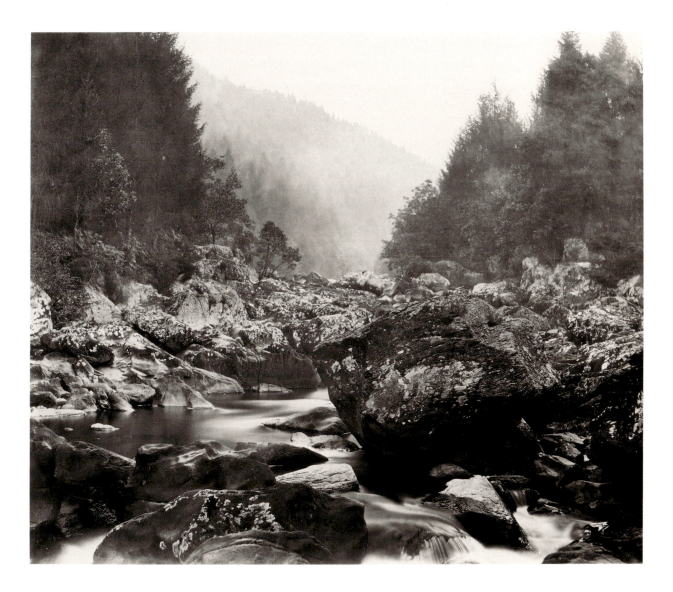

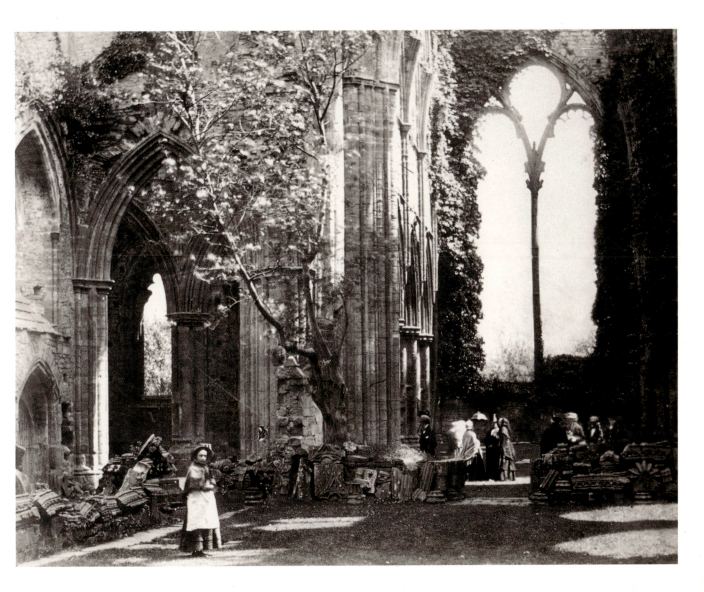

PHOTOGRAPHS

CHRONOLOGY

1819 Roger Fenton born at Crimble Hall in Heywood, near Rochdale, Lancashire, England.

1838 Began studies at University College, London.

1841–44 Studied painting in Paris at the studio of Paul Delaroche.

1847 Qualified as a solicitor. Helped to form the Photographic Club (Calotype Club). Married Grace Maynard.

1851 Called to the Bar. The Great Exhibition held in London (the first exhibition to include photography).

1852 Society of Art's Photographic Exhibition held (the world's first photographic exhibition). Fenton's expedition to Russia.

1853 The Photographic Society founded (Fenton instrumental in the formation).

1854 Fenton commissioned by Queen Victoria to photograph the Royal Family. Also commissioned to record the art treasures of the British Museum.

1855 Commissioned to photograph the Crimean War by art dealer Thomas Agnew.

1856 Appointed chief photographer to the Photogalvanographic Company.

1862 Fenton abandoned photography and returned to his law practice as a solicitor.

1869 Fenton died at 2 Albert Terrace, Regents Park, London.

SELECTED BIBLIOGRAPHY

Beaton, Cecil, and Buckland, Gail. *The Magic Image: The Genius of Photography*, 1939 to the present day. Boston: Little, Brown, and Co, 1975.

Dimond, Frances, and Taylor, Roger. *Crown and Camera: The Royal Family and Photography, 1842–1910*. Harmondsworth, Middlesex, England: Penguin Books Ltd., 1987.

Gernsheim, Helmut and Alison. *Roger Fenton: Photographer of the Crimean War*. (The Literature of Photography Series) Salem, New Hampshire: Ayer Co. Publications, 1954, reprint 1973.

Goldschmidt, Lucien, and Naef, Weston J. *The Truthful Lens: A Survey of the Photographically Illustrated Book, 1844–1914*. University Press of Virginia, 1980.

Hannavy, John. *Roger Fenton of Crimble Hall*. Boston: David R. Godine, 1976.

Lucie-Smith, Edward. *The Invented Eye: Masterpieces of Photography 1839–1914*. London: Paddington Press, 1975.

Thackrey, Sean H. *Masterworks of the Rubel Collection*. Sacramento: The Crocker Art Museum, 1982.

Witkin, Lee D. and London, Barbara. *The Photograph Collector's Guide*. New York Graphic Society Books, 1979.

A Treatise of Usurie. (English Experience Series, No. 736) Norwood, New Jersey: Walter J. Johnson, Inc., 1975.